Mysterious Beauty

DESERT PLANTS
AND CACTI OF
THE AMERICAS

A Postcard Collection

22 Removable Picture Postcards

SQUAREBOOKS
BOOK ◆ CARDS

This book is lovingly dedicated to
the memory of Dr. Pierre Claude Fischer, Botanist

Book-O-Cards is a registered trademark of Squarebooks, Inc.

Copyright © 2002 by Squarebooks, Inc.

Photographs copyright by the family of Pierre C. Fischer.

Design by Tarane' Sayler, Sayler Design Works
Special thanks to Ian Price, Lone Pine Gardens

Much appreciation to Baron Wolman: for taking an idea and making it reality

ISBN: 0-916290-82-4

SQUAREBOOKS
P.O. Box 6699 • Santa Rosa, CA 95406 • Tel: 707-545-1221 • Fax: 707-545-0909
www.squarebooks.biz

PRINTED IN KOREA

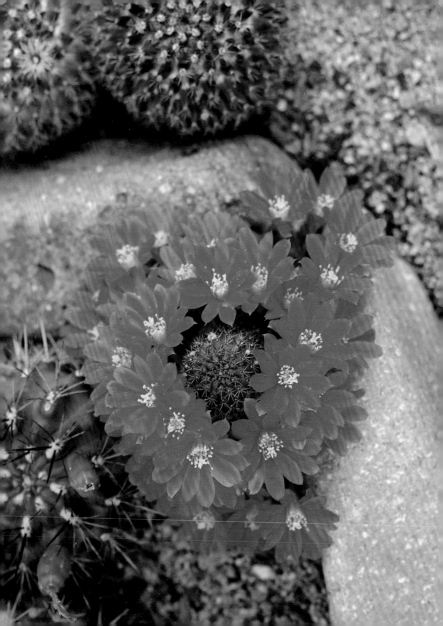

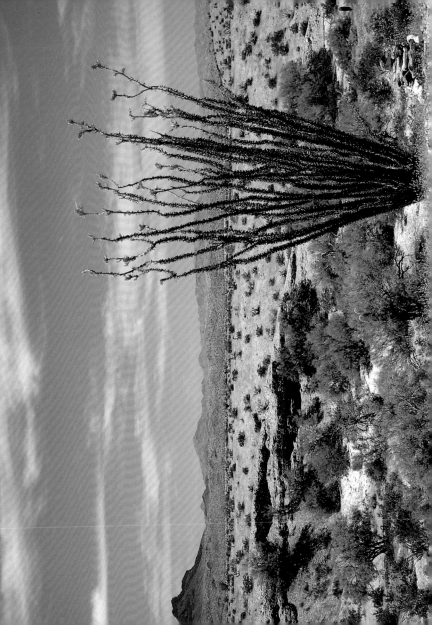

Fouquieria splendens
Ocotillo in bloom
Southwest United States

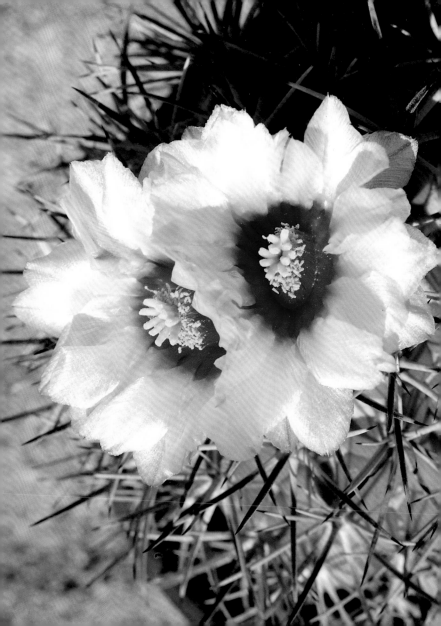

Coryphantha poselgeriana
Mexico

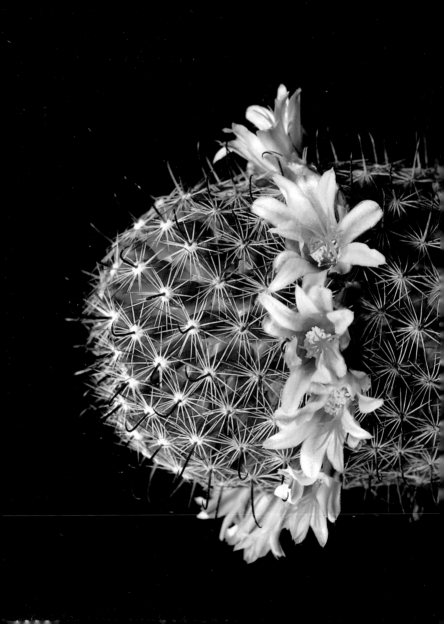

Mammillaria dioica
Baja California

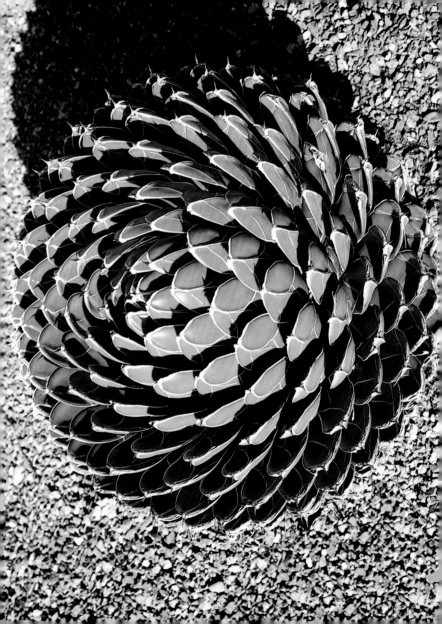

Agave victoria-reginae
Southwest United States

PHOTOGRAPH COPYRIGHT © BY THE FAMILY OF PIERRE C. FISCHER

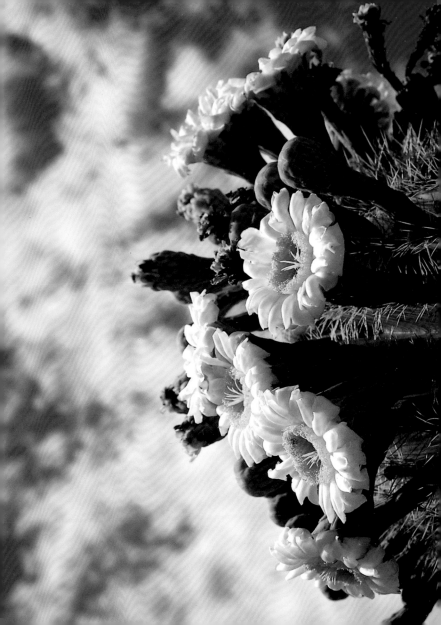

Carnegiea gigantea,
aka Cereus giganteus
Saguaro flowers
Arizona

PHOTOGRAPH COPYRIGHT © BY THE FAMILY OF PIERRE C. FISCHER

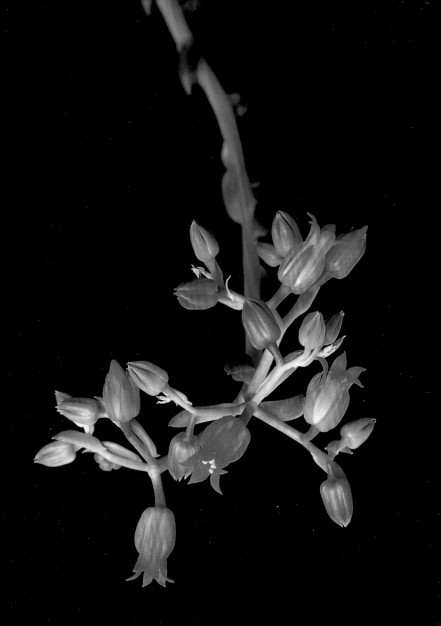

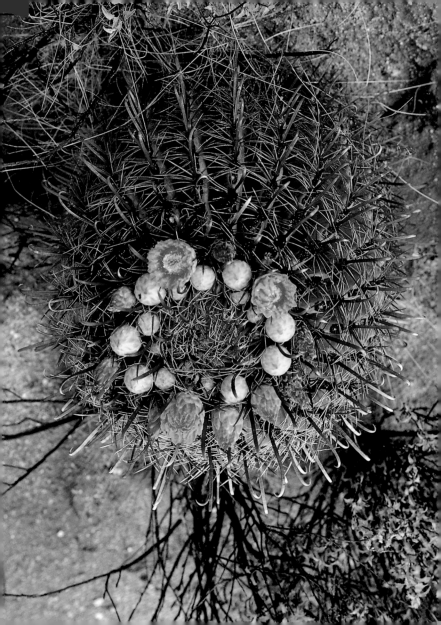

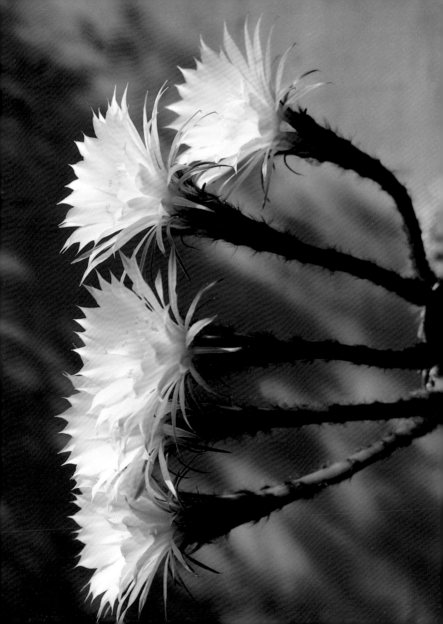

Echinopsis mirabilis
South America

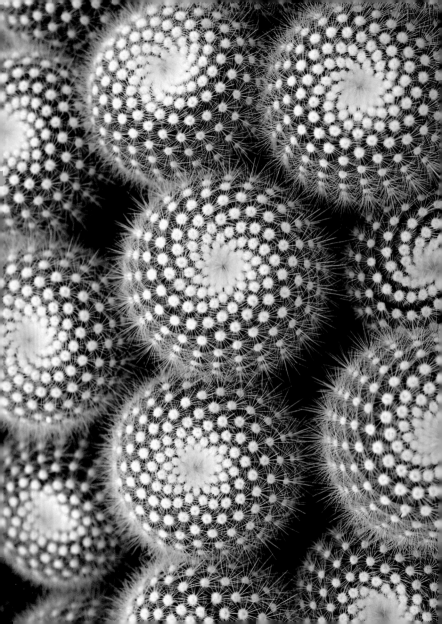

Cactus flat of Notocactus

South America

Castilleja
Indian Paint Brush
Southwest United States

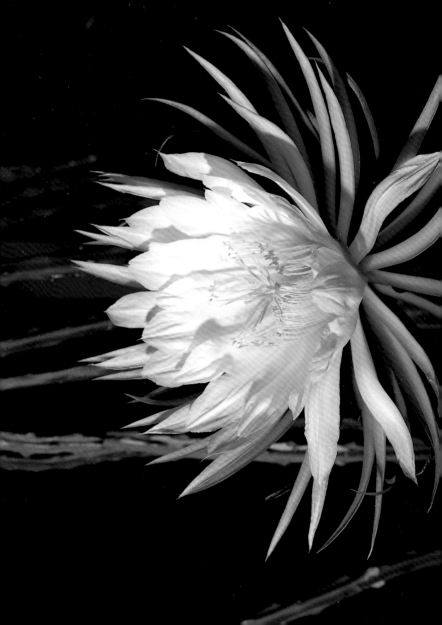

Selenicereus macdonaldiae

Queen of the Night

Honduras, Mexico, South America

BOOK ◇ CARDS

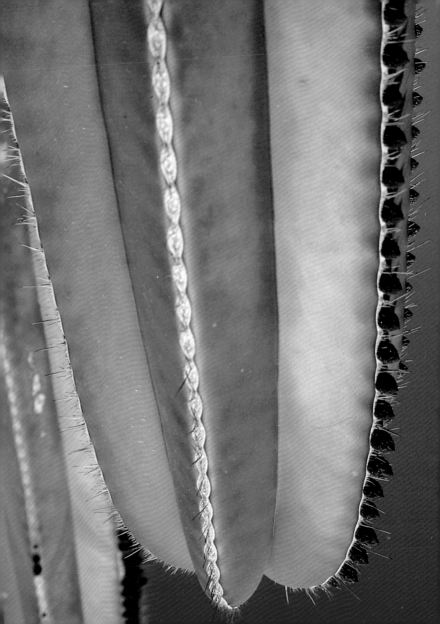

Marginatocereus marginatus
Organ Pipe
Arizona and Mexico

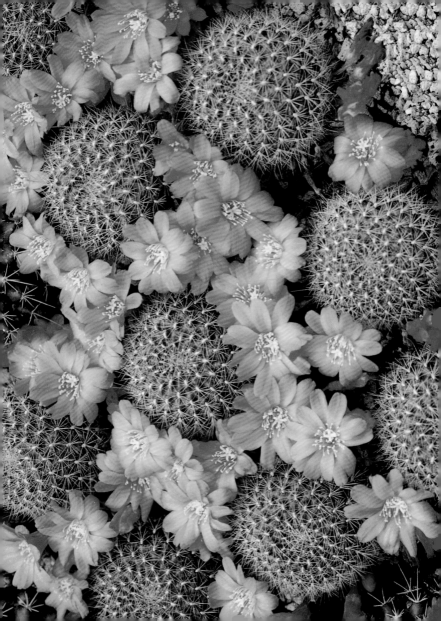

—

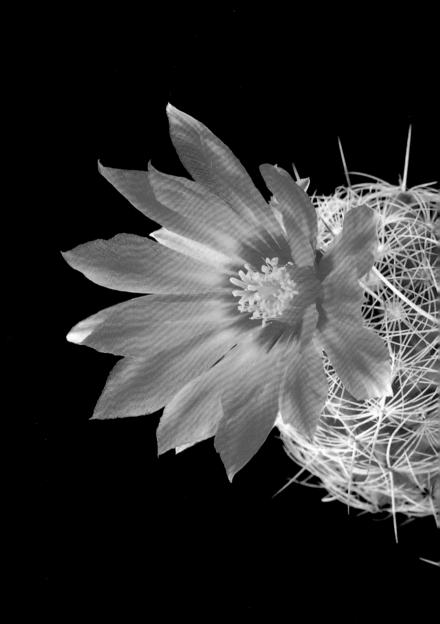

Thelocactus bicolor
v. flavidispinus
Texas, Mexico

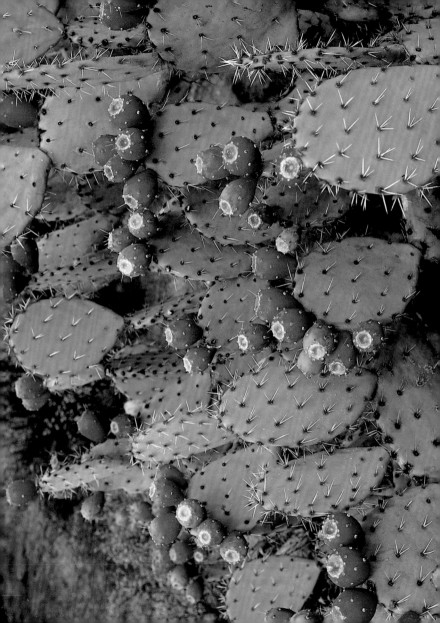

BOOK ◆ CARDS

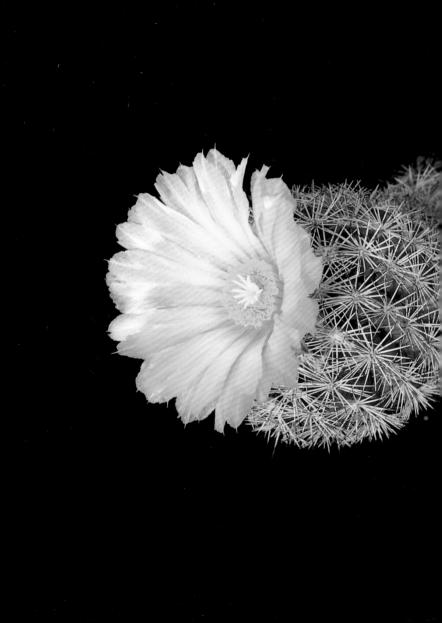

Coryphantha densispina
Mexico

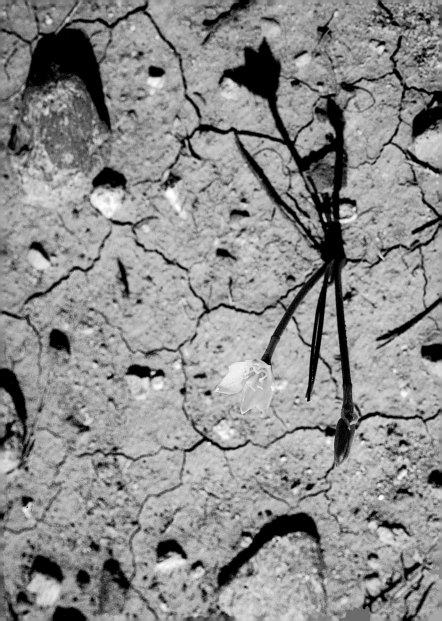

Zephyranthes longiflora
Zephyr Lily
Texas

PHOTOGRAPH COPYRIGHT © BY THE FAMILY OF PIERRE C. FISCHER

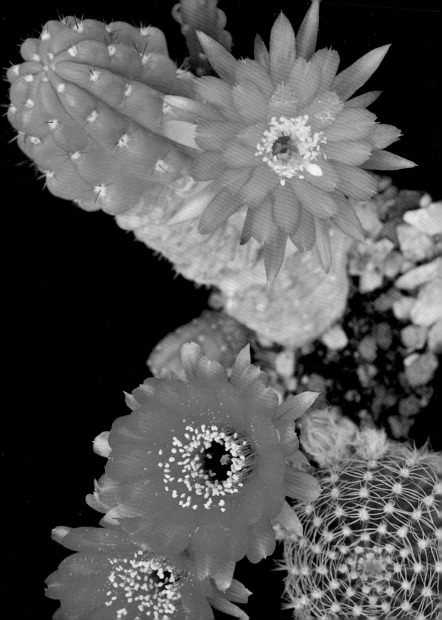

Lobivia caespitosa
South America

BOOK ◆ CARDS

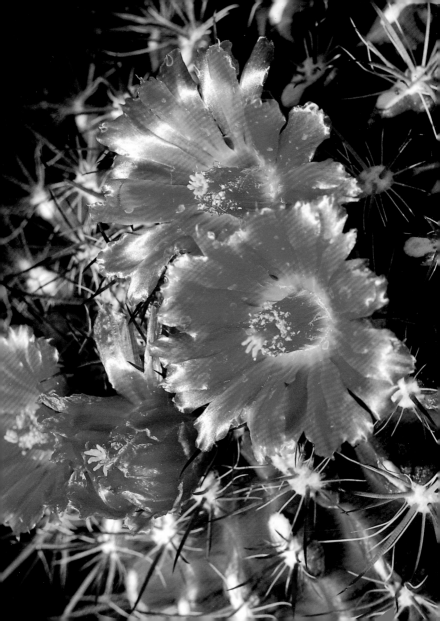

Ferocactus fordii
West coast of Baja, Mexico

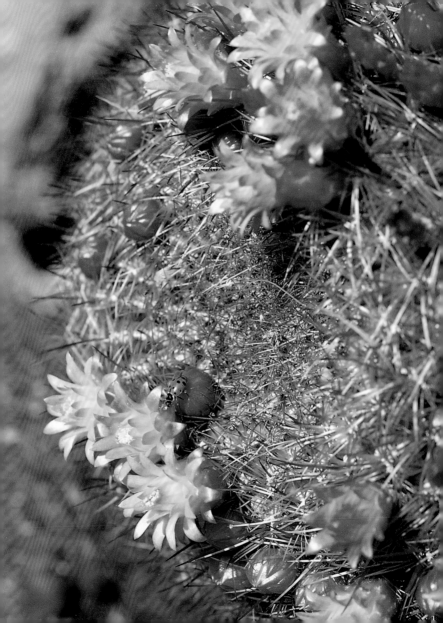

Oroya peruviana
South America

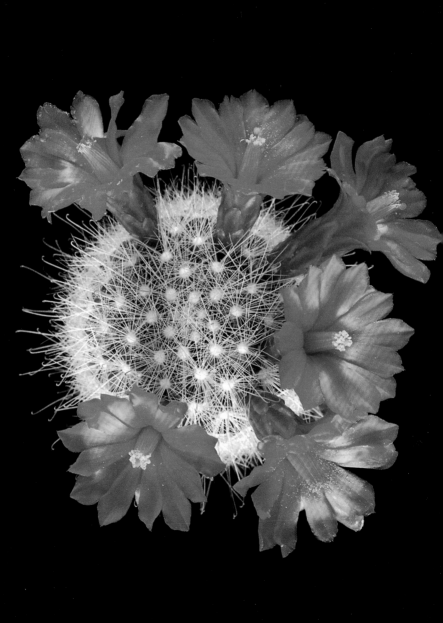

Pierre Fischer

Pierre Fischer was born in Paris, France in 1929. During World War II, his family emigrated to New York City. He attended New York City College, University of Maine, Harvard University, University of Arizona and University of California at Berkeley. His studies included chemistry and mathematics, but it was botany that captured his imagination, especially cacti. Pierre became an intrepid seeker and observer of desert plant life, traveling the entire North American Southwest and Mexico, and trekking through Madagascar, collecting plants and seeds and always committing the experience to film. During his many years living in Arizona, with cameras slung over his shoulder, he led educational hikes through the desert, pointing out the unexpected beauty to be found with every step. Pierre was an educator and photographer who lived his life in exploration and admiration of these fascinating plants. For decades he sought to understand their secrets, their ability to thrive under harsh conditions and their unimaginable beauty when they revealed their hidden mysteries.

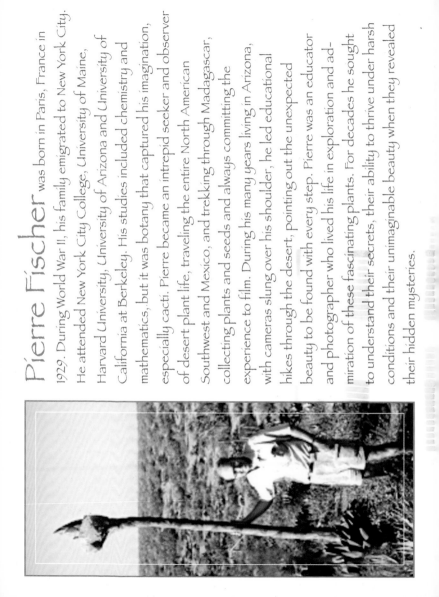

Copies of **Mysterious Beauty**
are available from Squarebooks for $9.95 each.
California residents please add sales tax.
Shipping and handling are $3.95 for the first postcard book;
add $1.00 for each additional copy.

Mail your order to:
Squarebooks, P.O. Box 6699, Santa Rosa, CA 95406.
Or, phone your order toll-free:
1-800-345-6699

E-mail us at sales@squarebooks.biz
You may pay by check, money order or major credit card.

For information regarding our other publications,
please visit our website: www.squarebooks.biz

Squarebooks welcomes retail accounts; ask about our quantity discounts.